W9-ATM-034

Woof

I Love Dogs

Woof

I Love Dogs

Featuring images by **Elliott Erwitt, Rachael Hale McKenna, Catherine Ledner & Gandee Vasan**

CHRONICLE BOOKS

SAN FRANCISCO

in association with PQ Blackwell

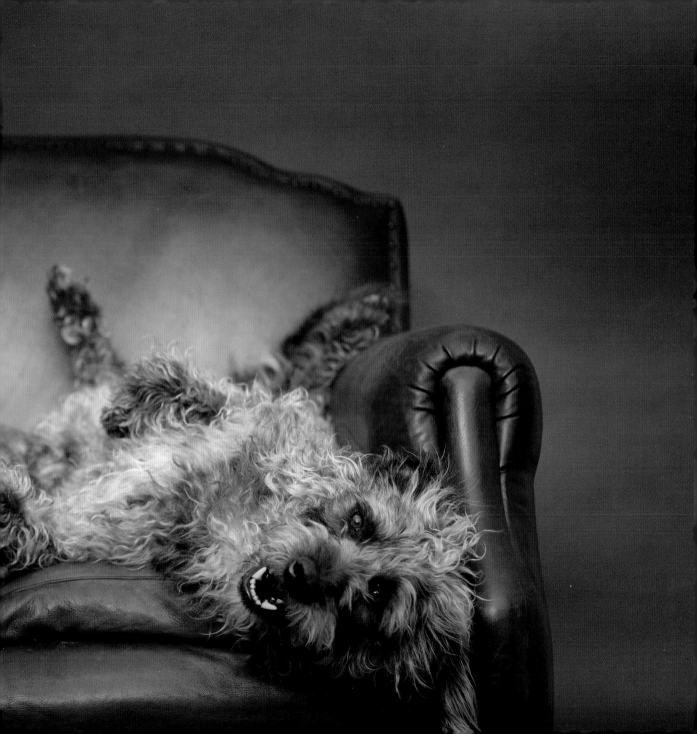

It is fatal to let any dog know that he is funny,
for he immediately loses his head and starts
hamming it up.

P G WODEHOUSE

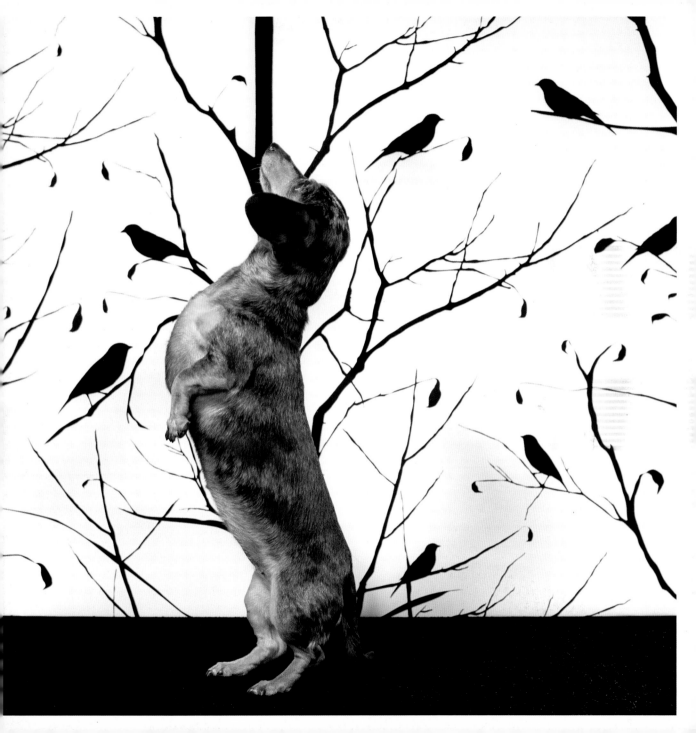

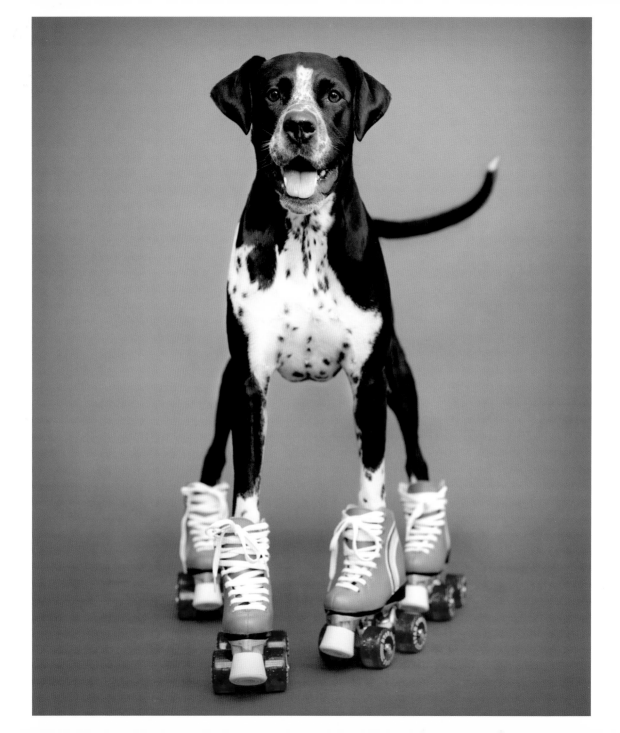

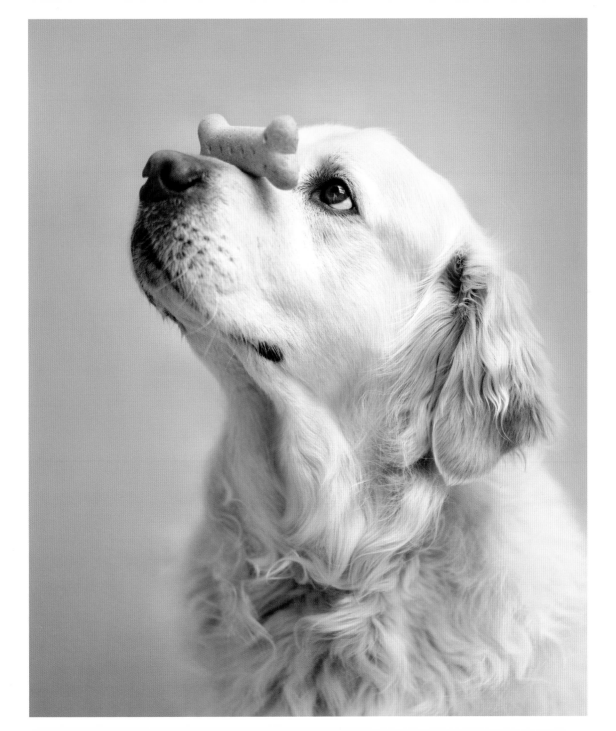

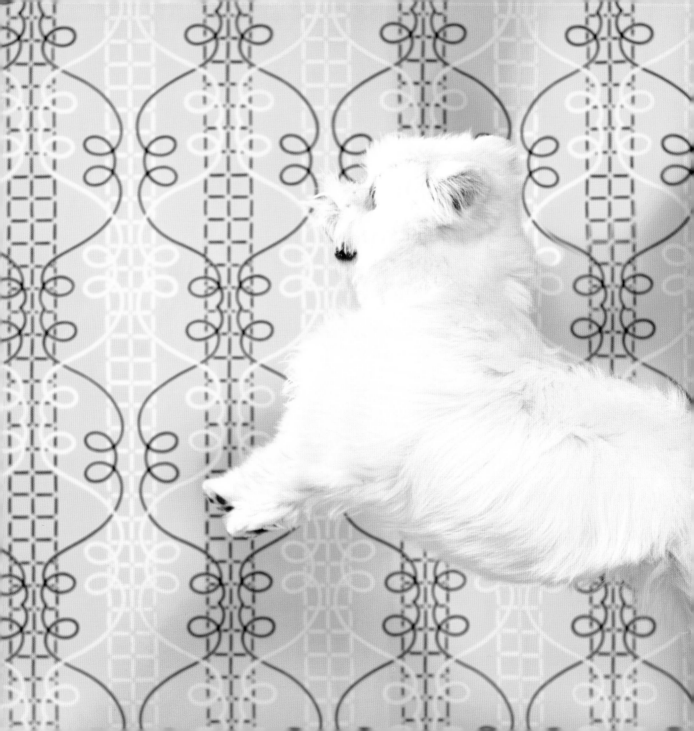

I don't think he has any idea

he's a dog, not really.

Of course, he thinks he has

a rather odd figure for a man.

DODIE SMITH

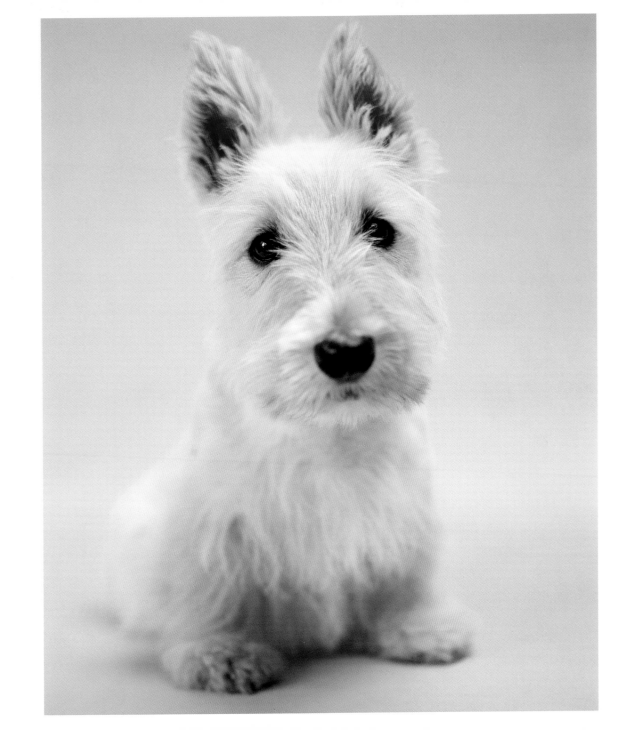

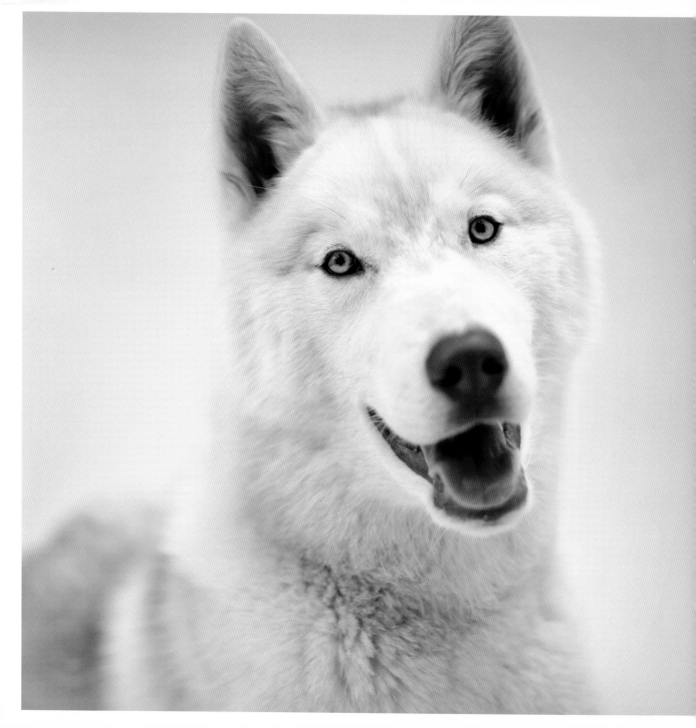

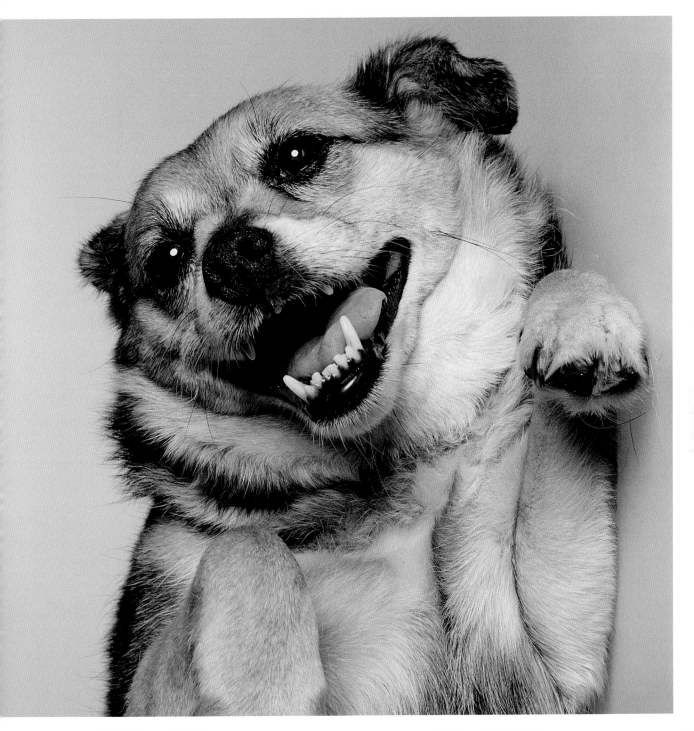

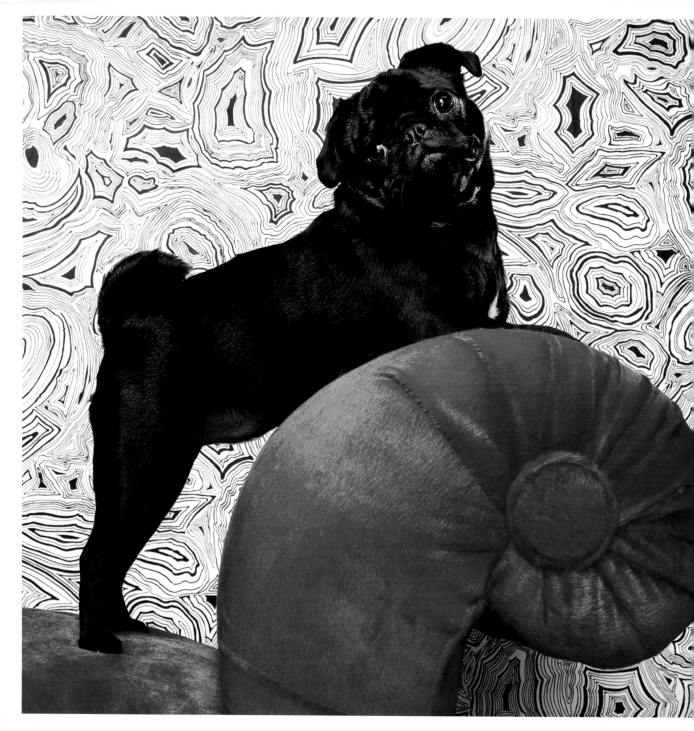

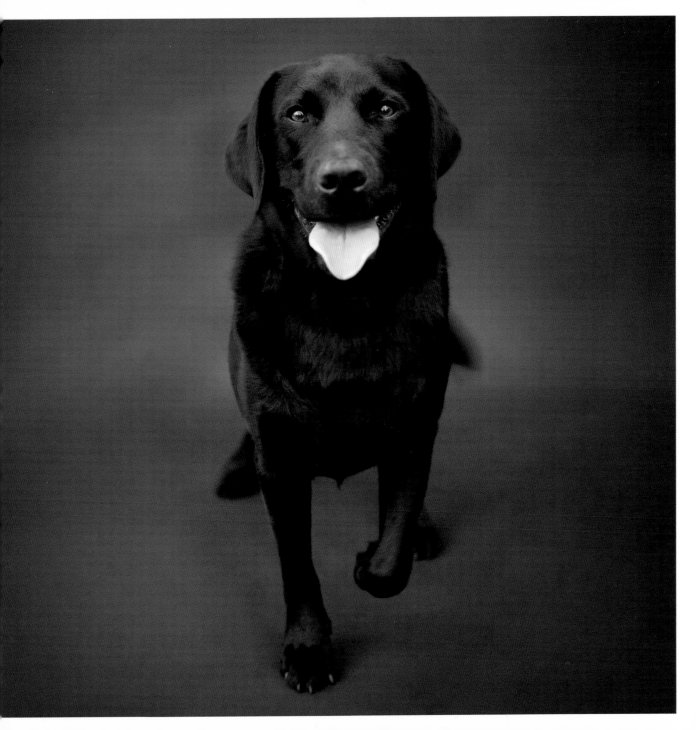

A dog has the soul of a philosopher.

PLATO

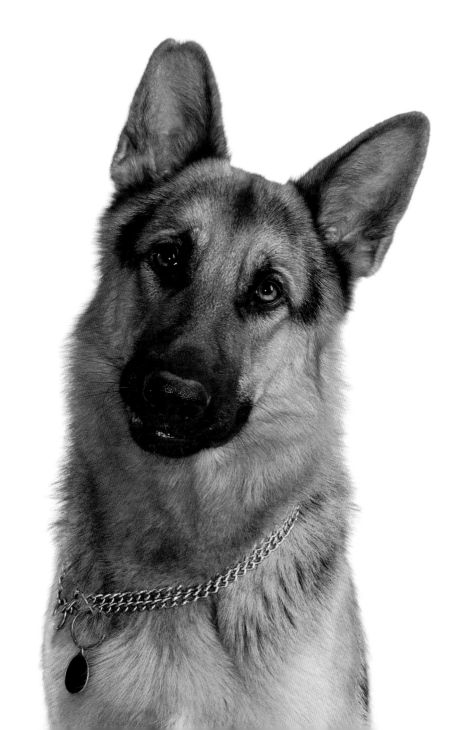

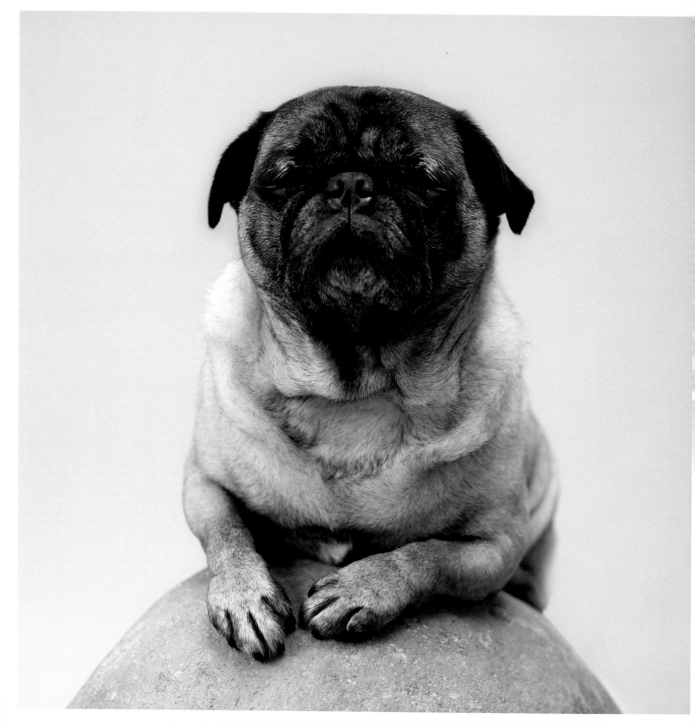

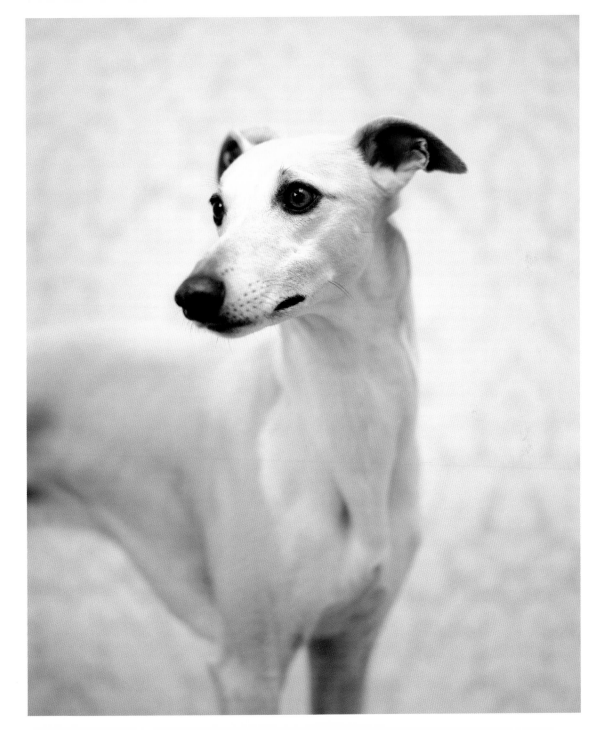

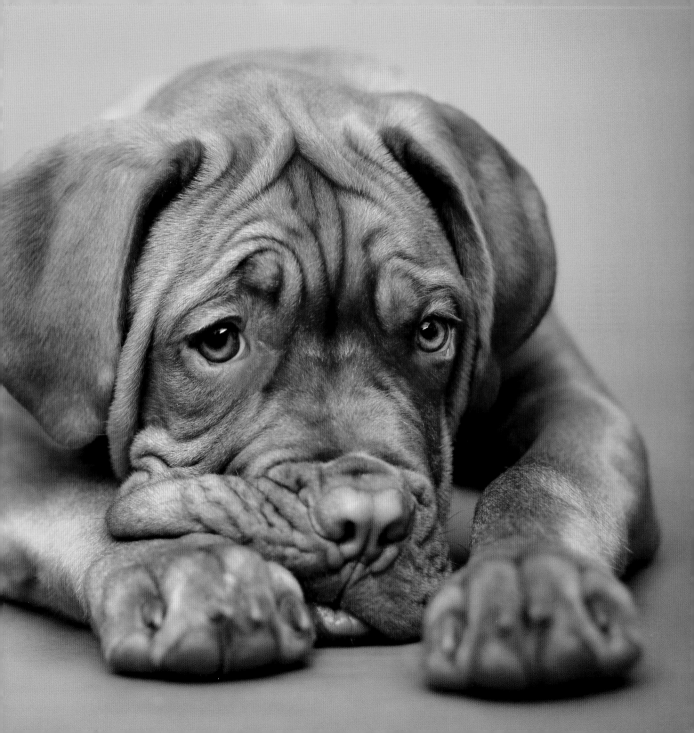

Scratch a dog and you'll find a permanent job.

FRANKLIN P JONES

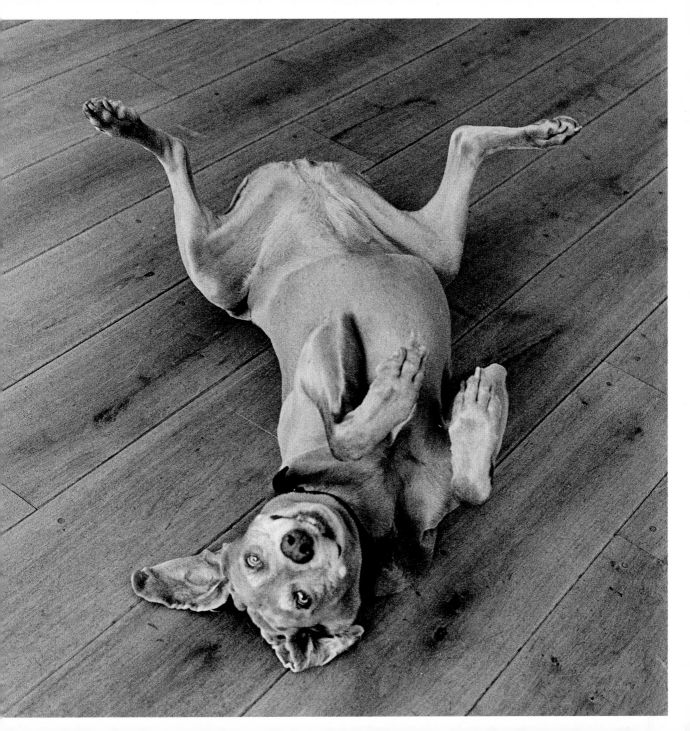

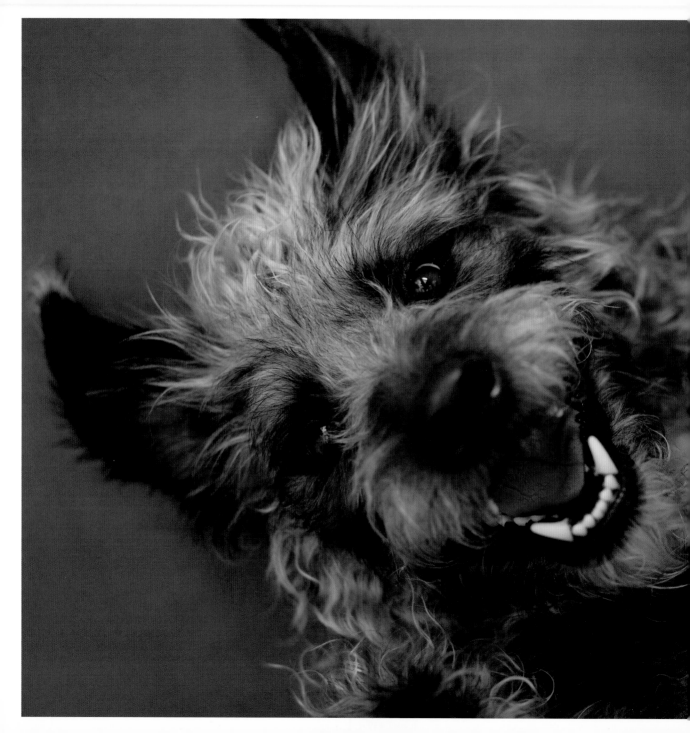

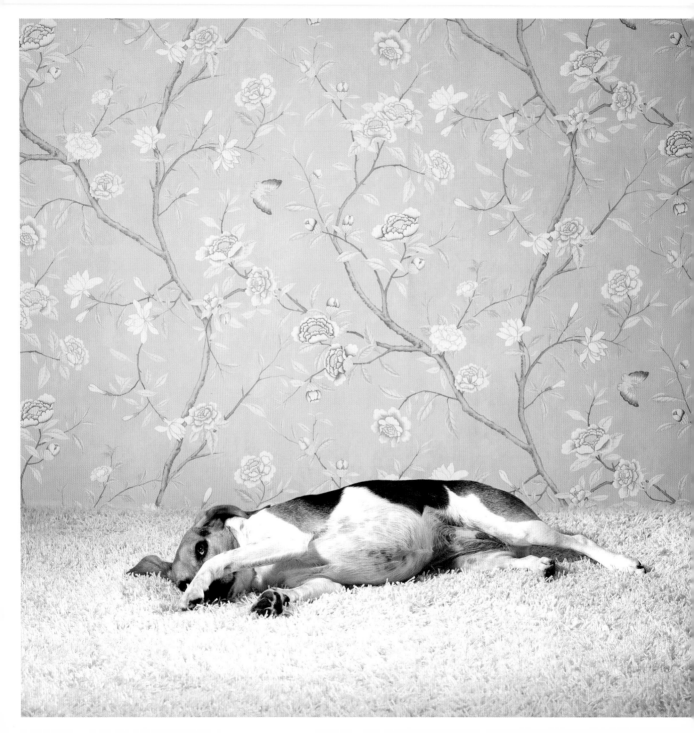

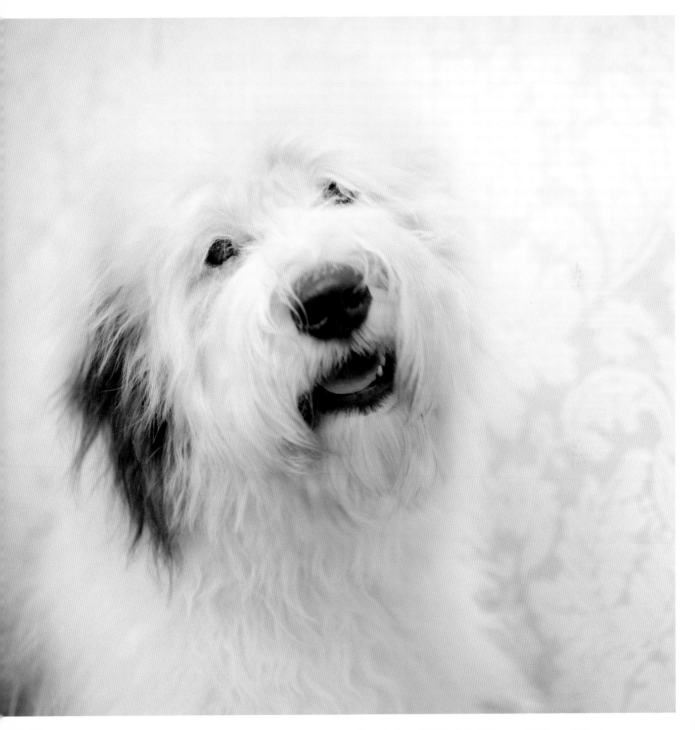

A dog is a dog . . .

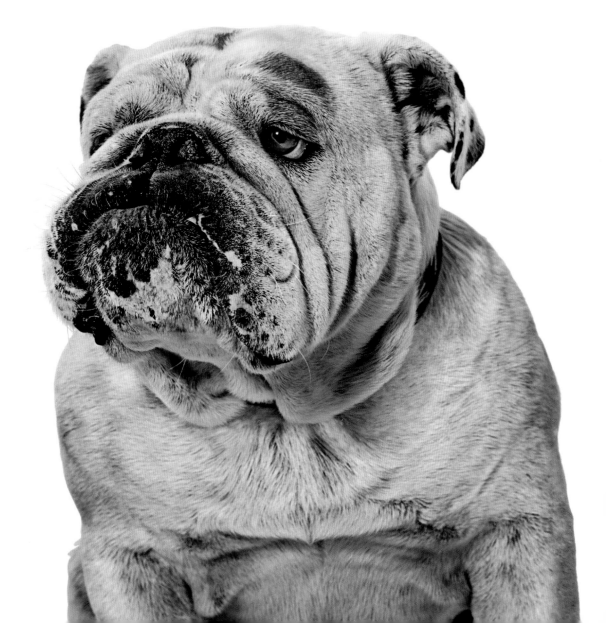

. . . except when he is facing you.

Then he is Mr Dog.

HAITIAN PROVERB

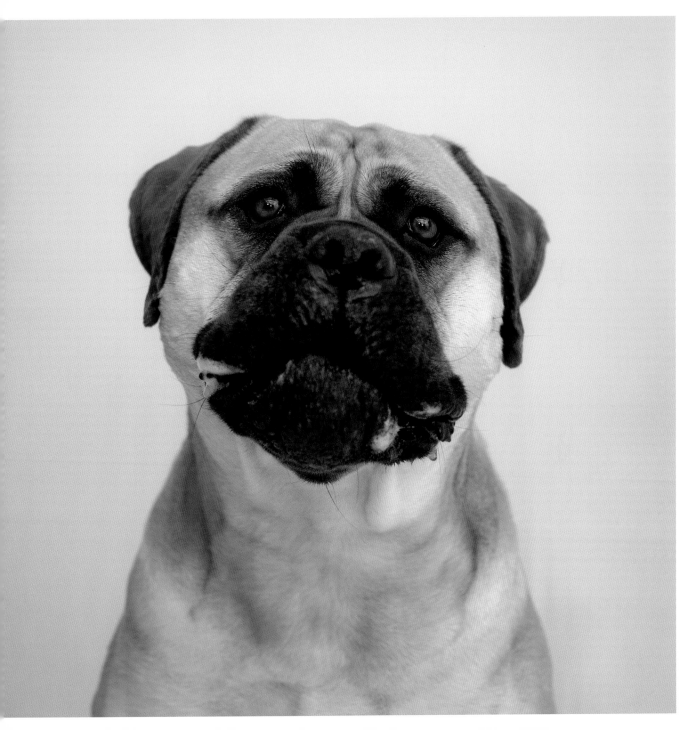

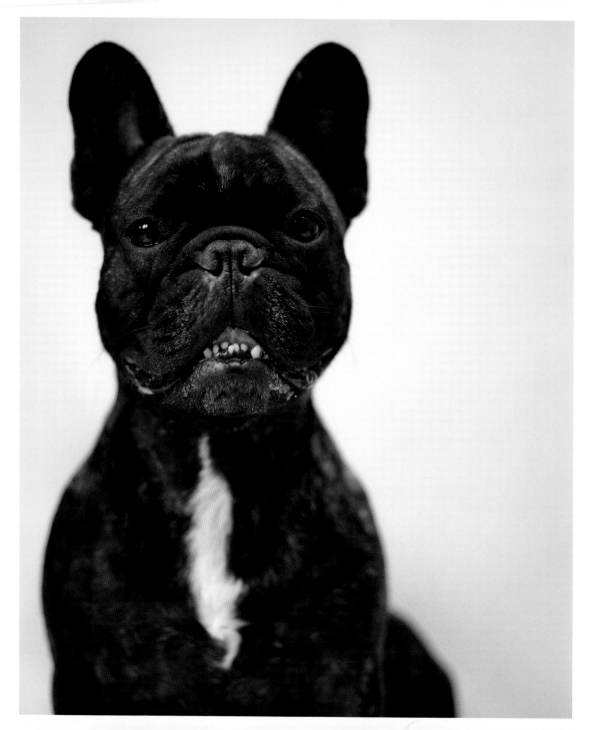

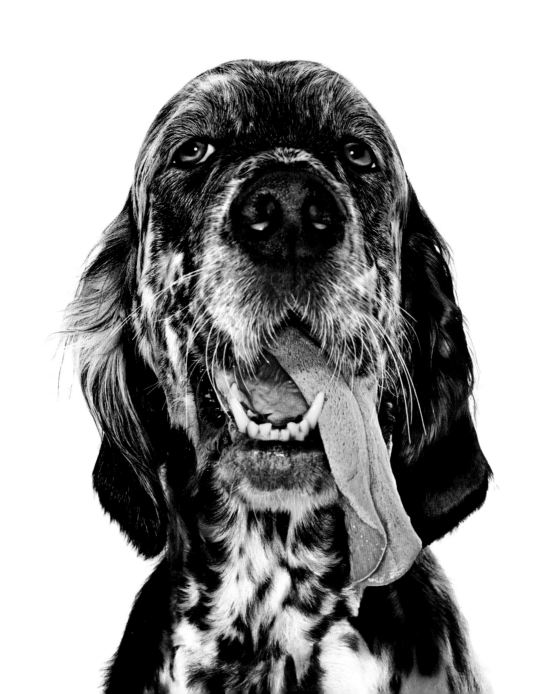

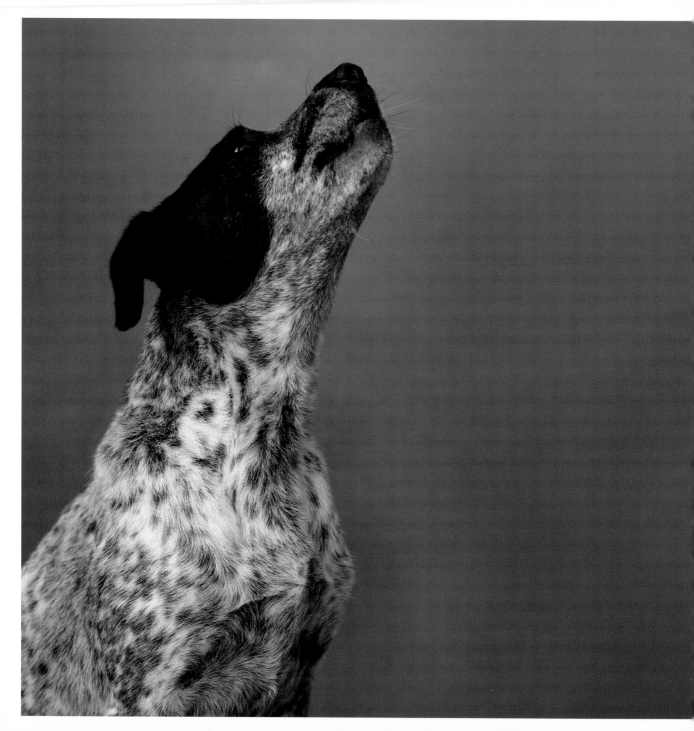

No one appreciates the very special genius

of your conversation as a dog does.

CHRISTOPHER MORLEY

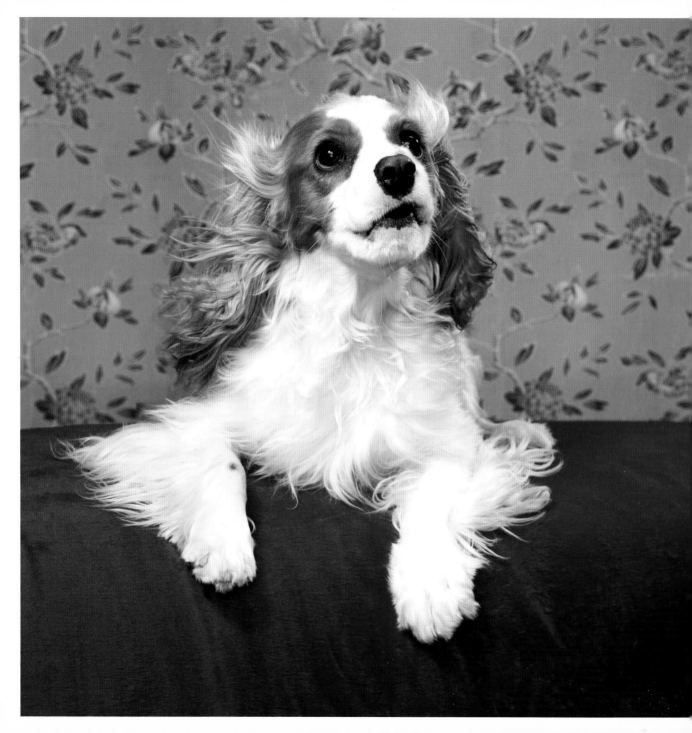

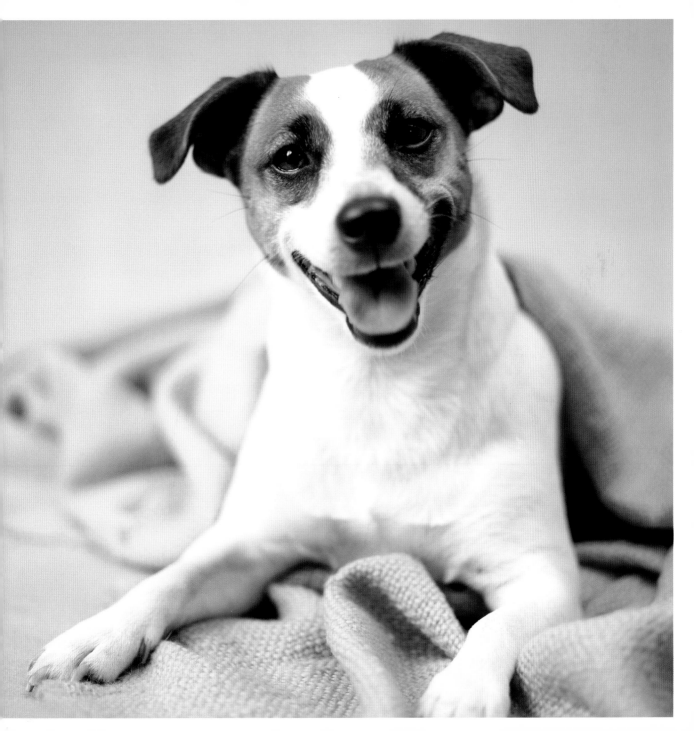

The average dog . . .

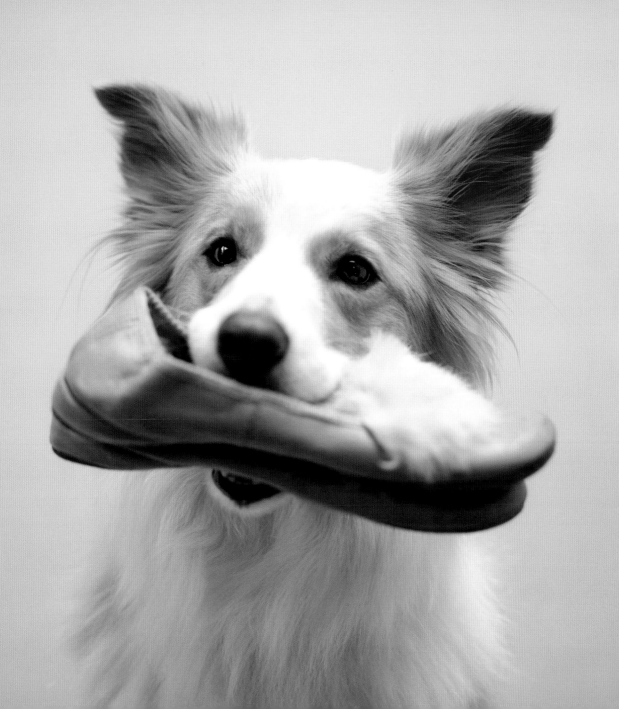

. . . is a nicer person than the average person.

ANDY ROONEY

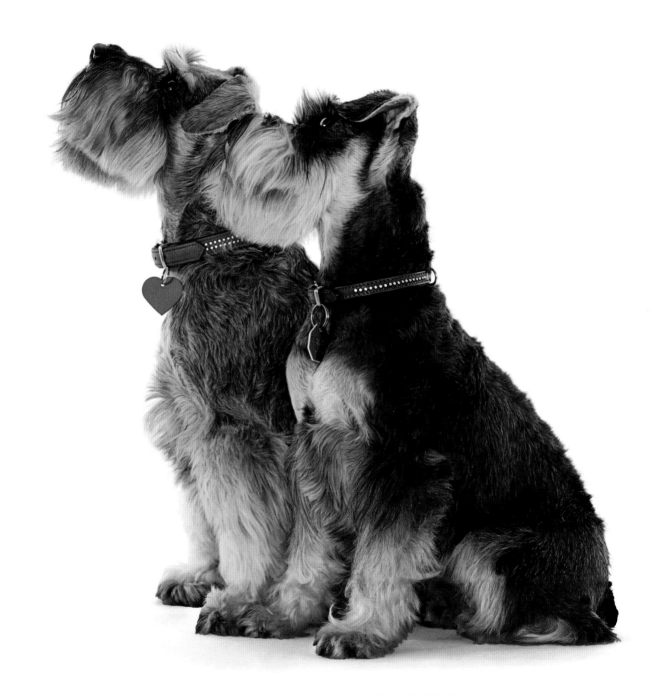

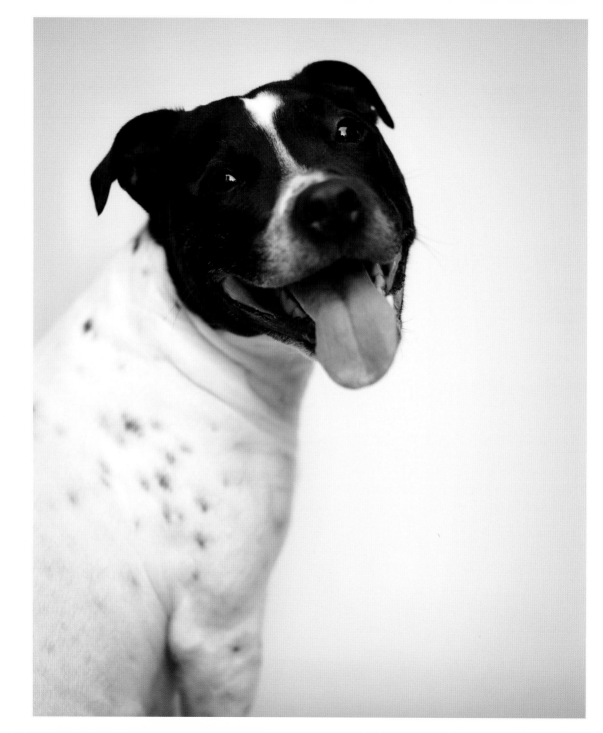

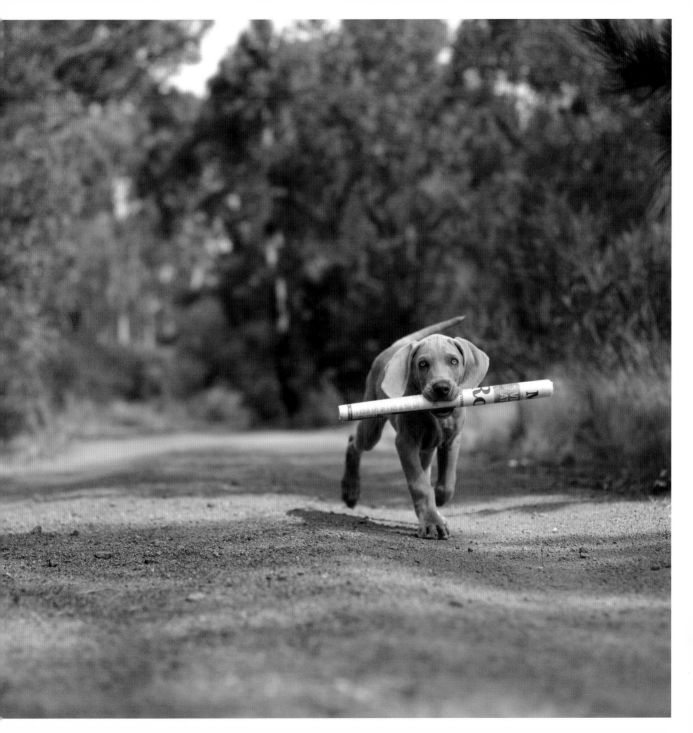

You may have a dog that won't sit up,

roll over, or even cook breakfast, not

because she's too stupid to learn how

but because she's too smart to bother.

RICK HOROWITZ

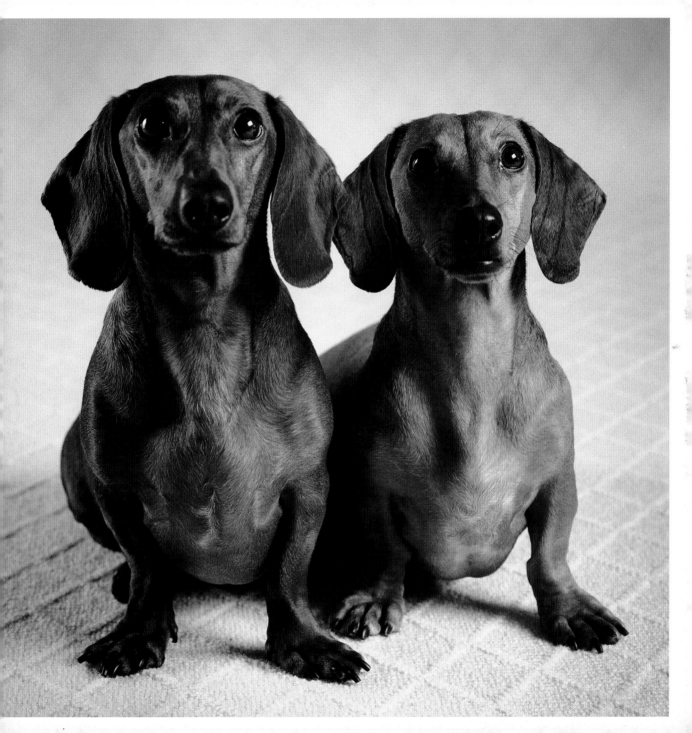

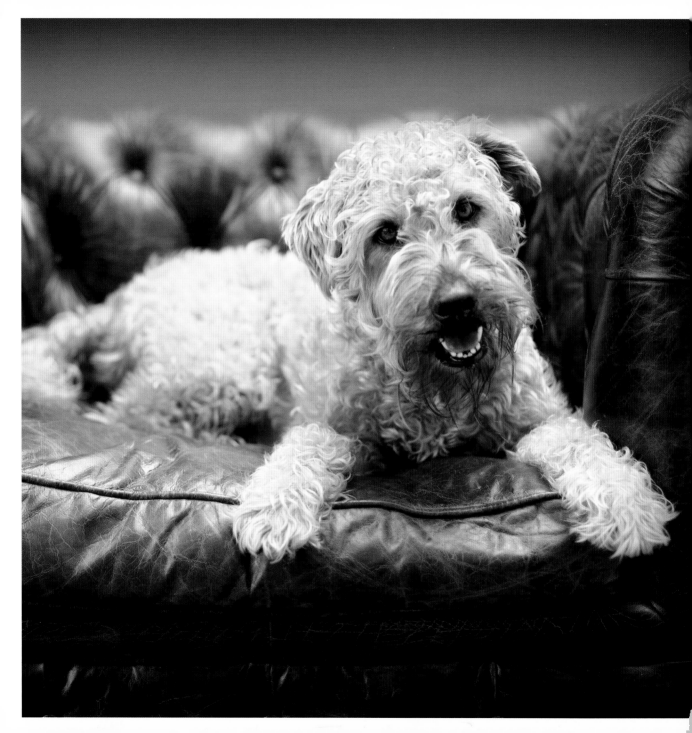

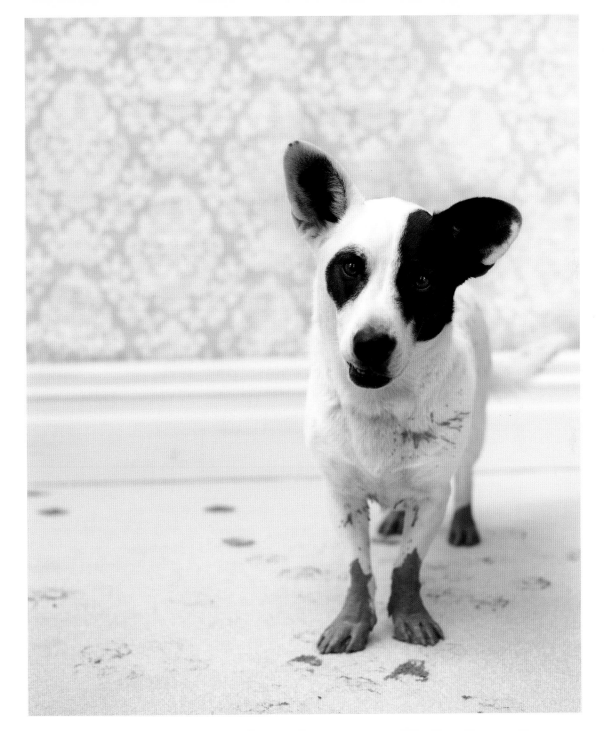

Who finds a faithful friend, finds a treasure.

JEWISH PROVERB

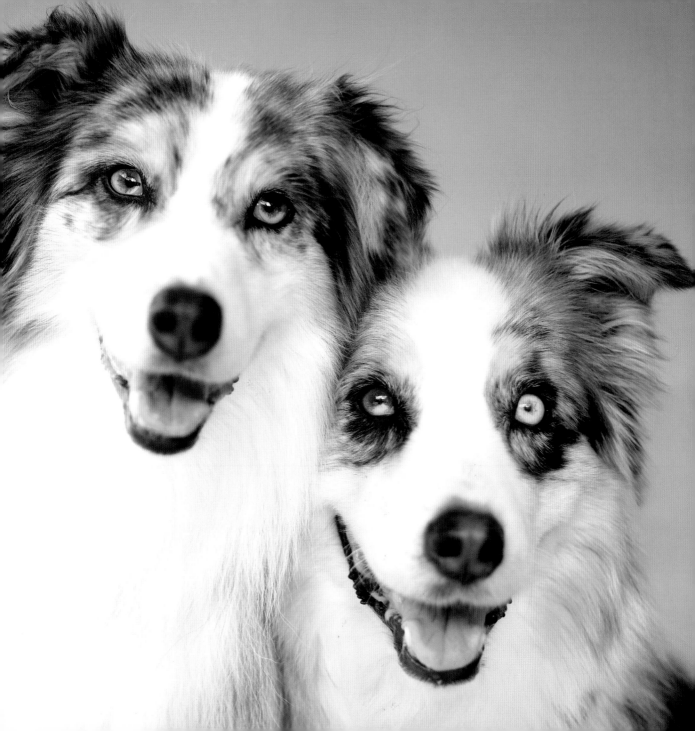

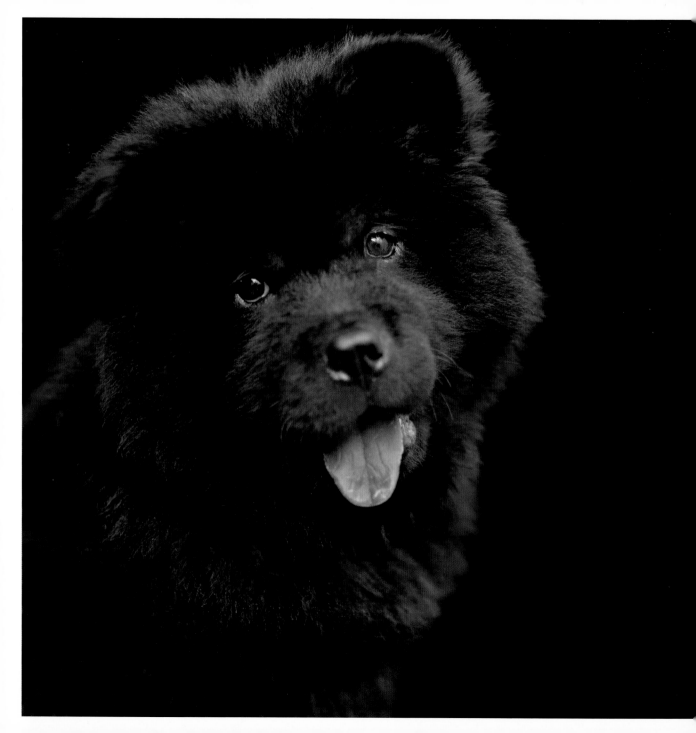

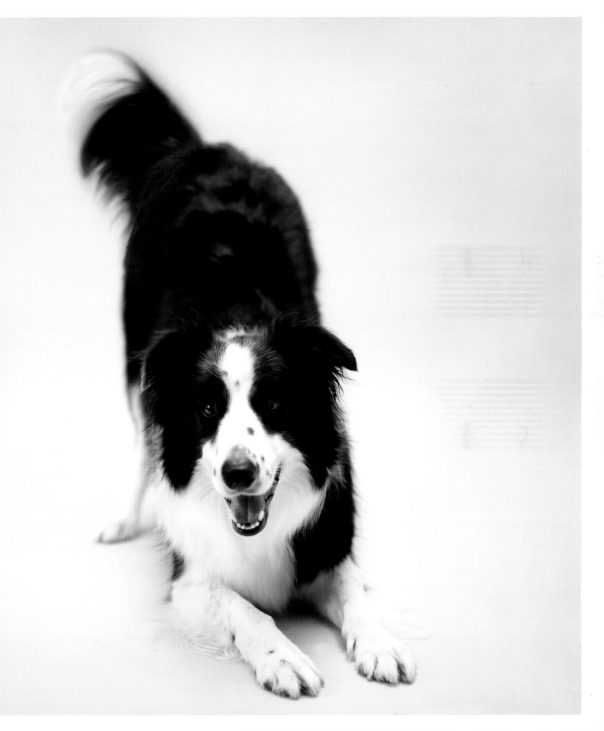

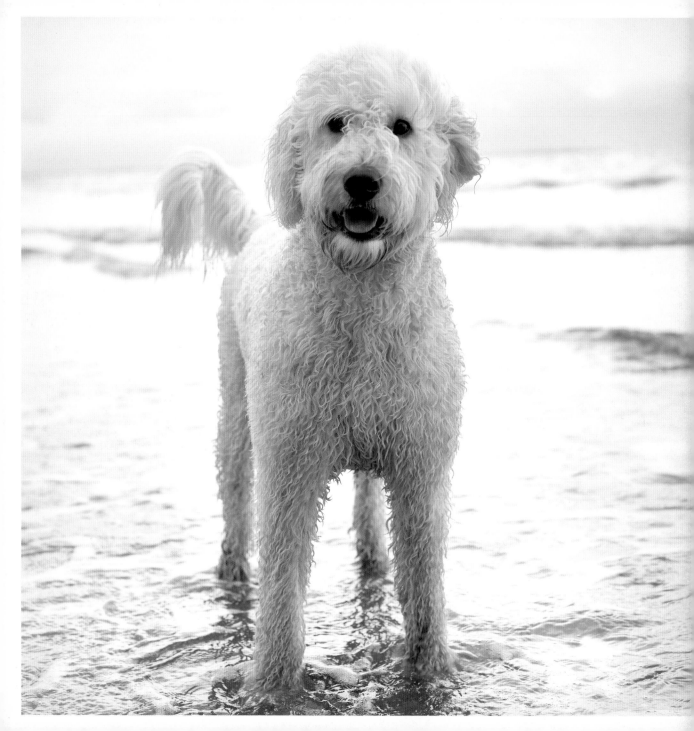

The most affectionate creature
in the world is a wet dog.

AMBROSE BIERCE

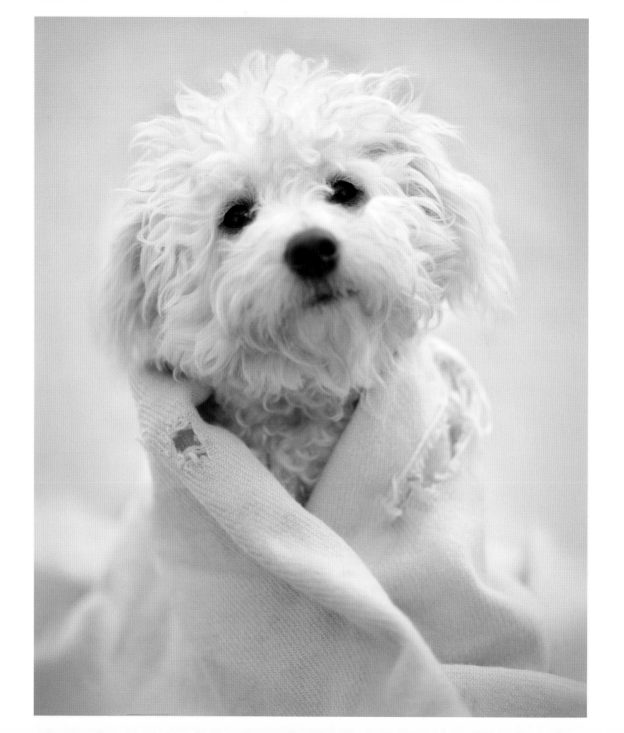

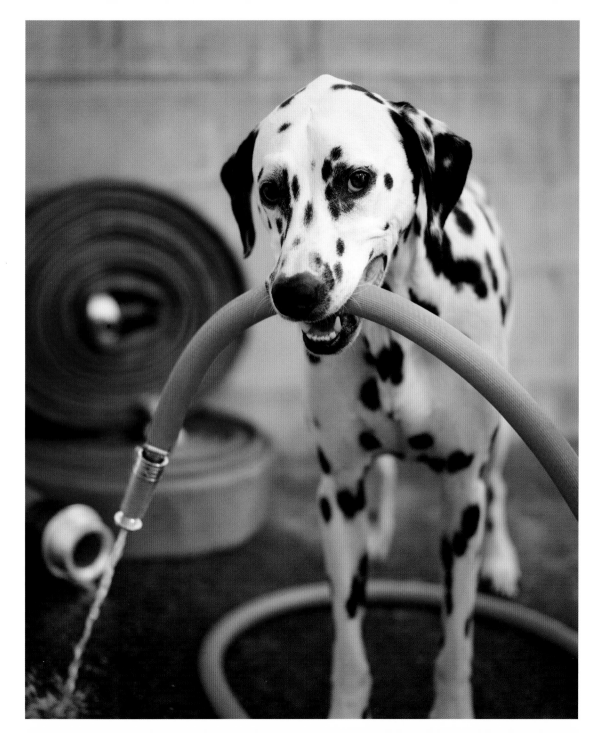

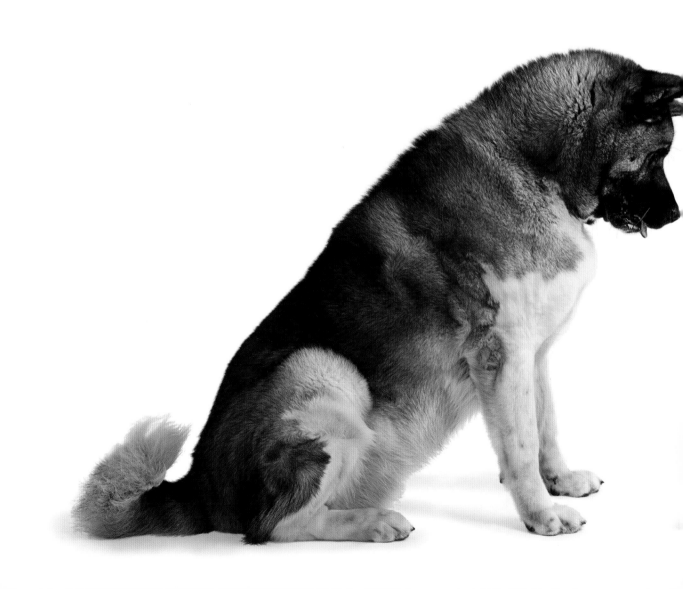

You can run with the big dogs
or sit on the porch and bark.

WALLACE ARNOLD

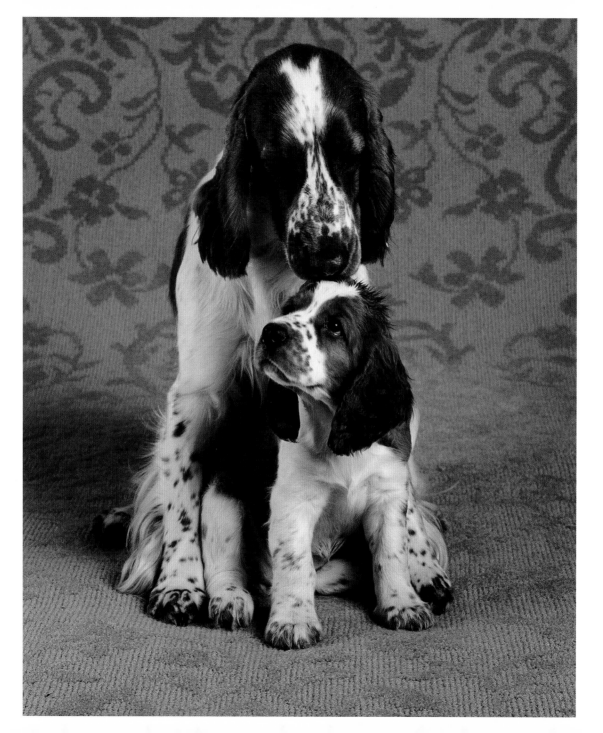

My little dog—a heartbeat at my feet.

EDITH WHARTON

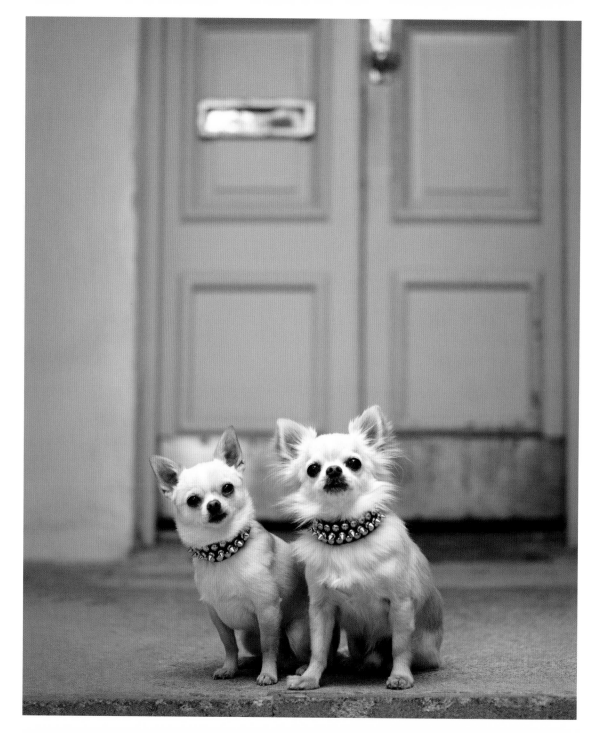

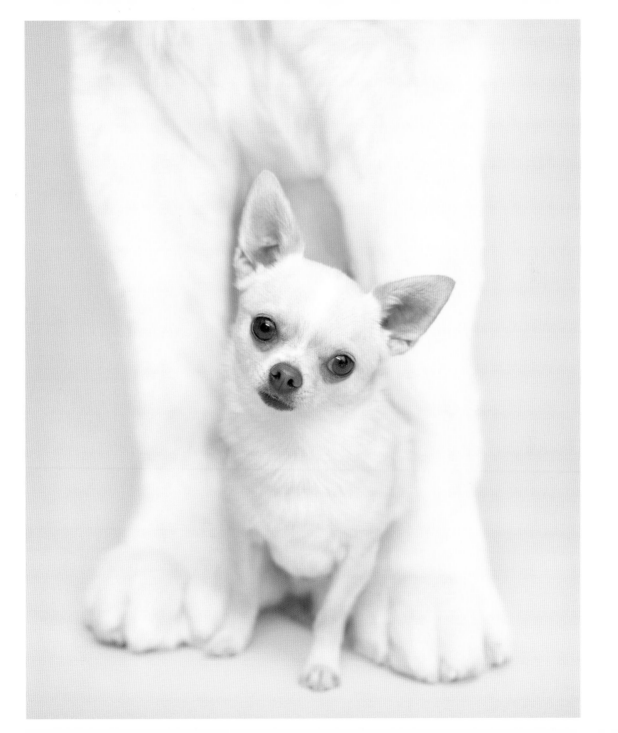

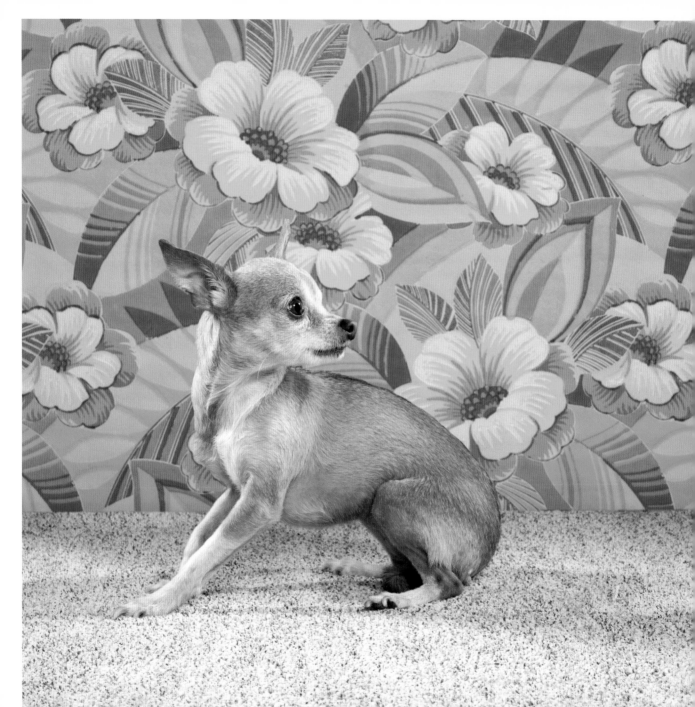

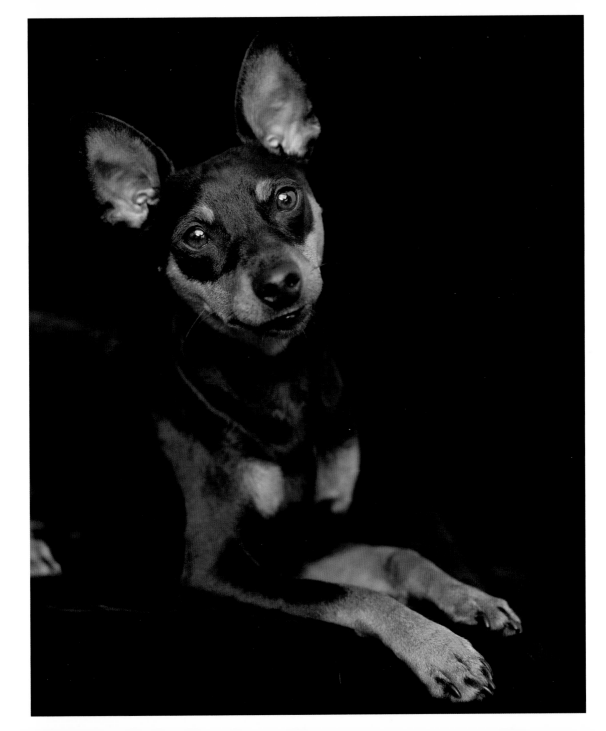

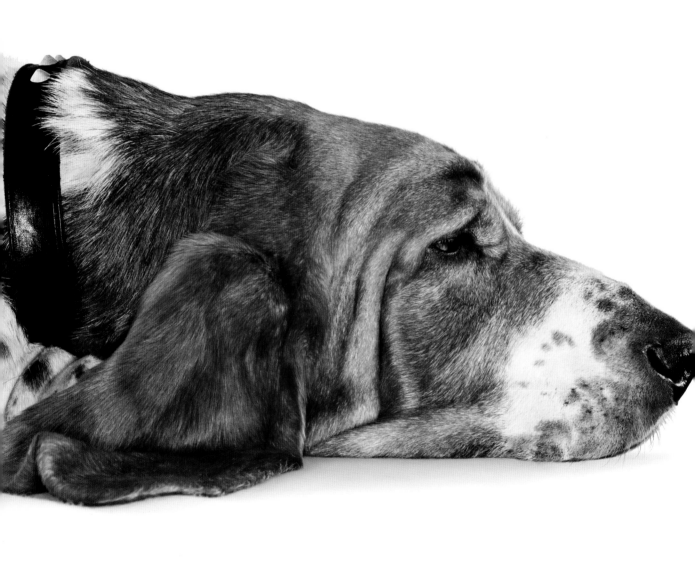

How beautiful it is to do nothing,

and then to rest afterward.

SPANISH PROVERB

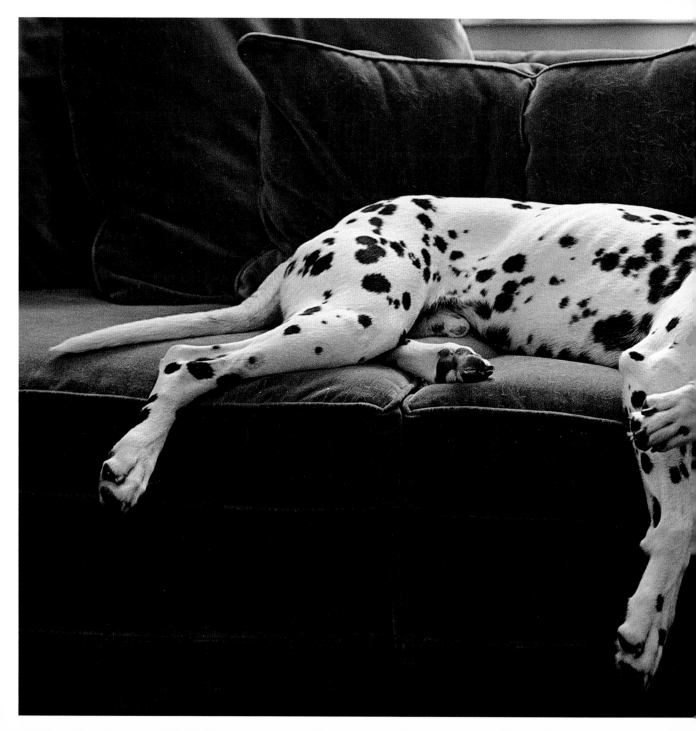

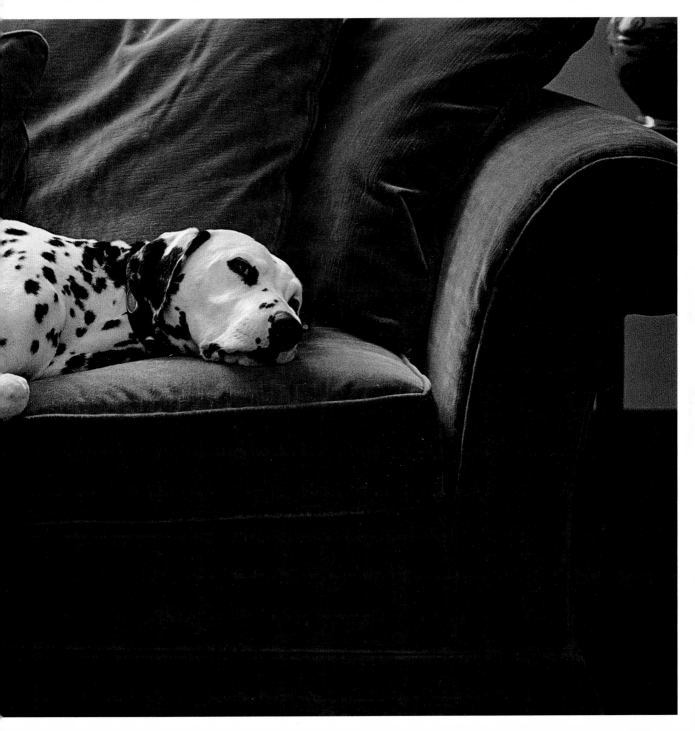

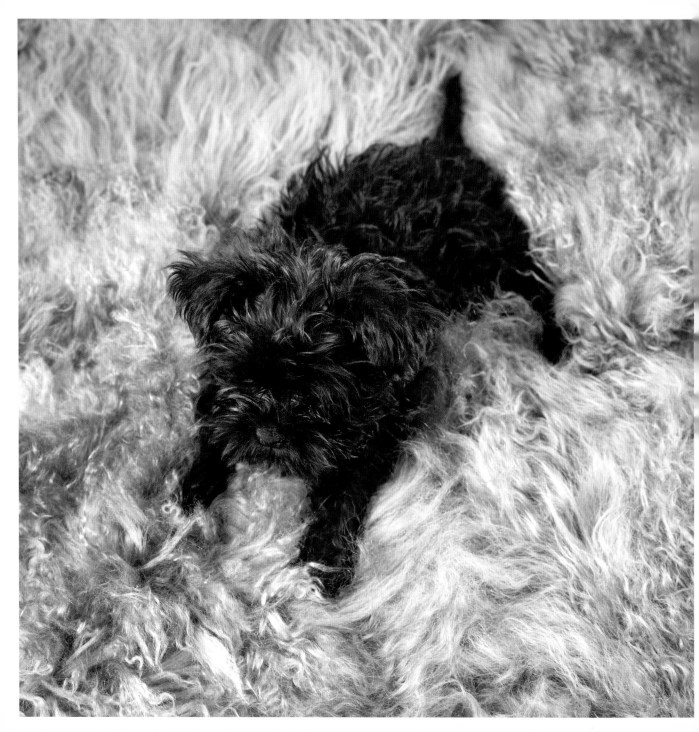

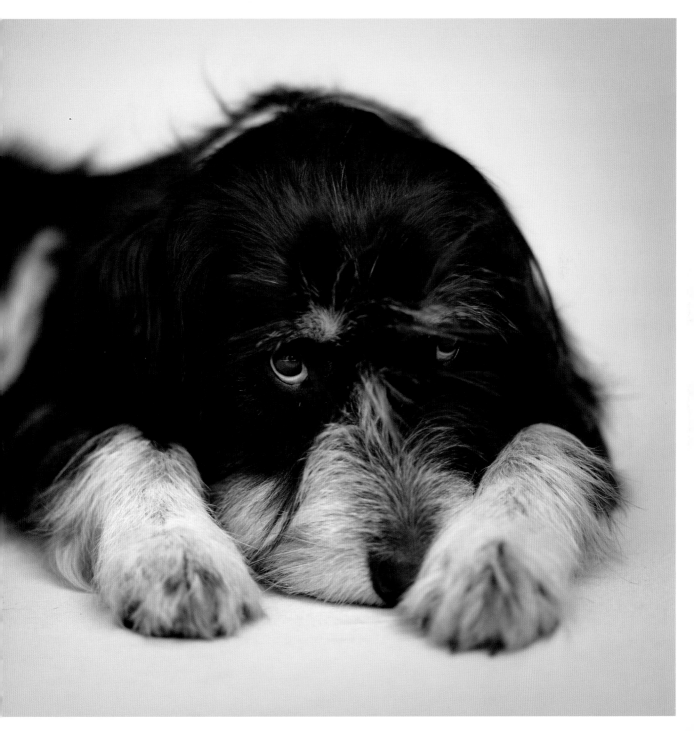

My best friend is the one who

brings out the best in me.

HENRY FORD

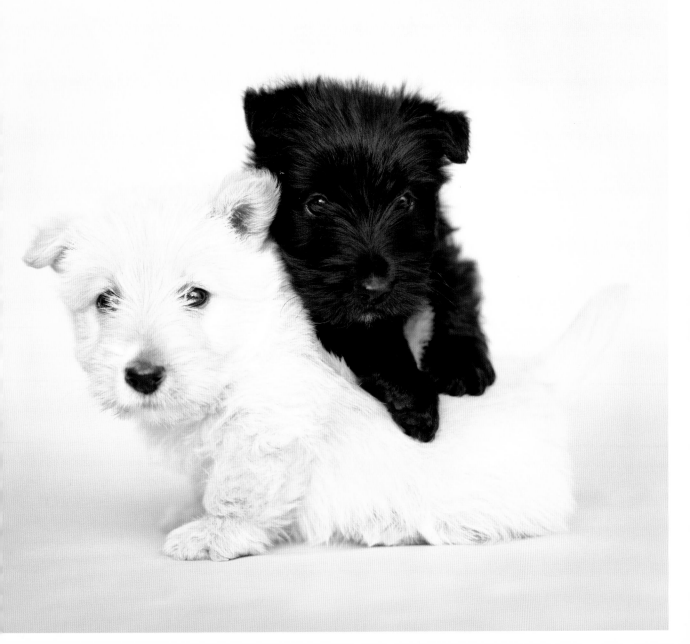

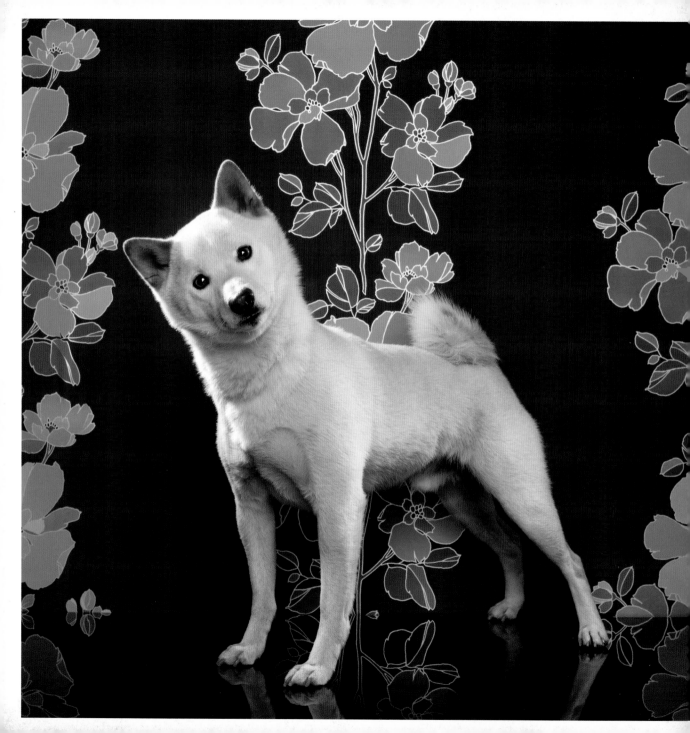

Our perfect companions never
have fewer than four feet.

COLETTE

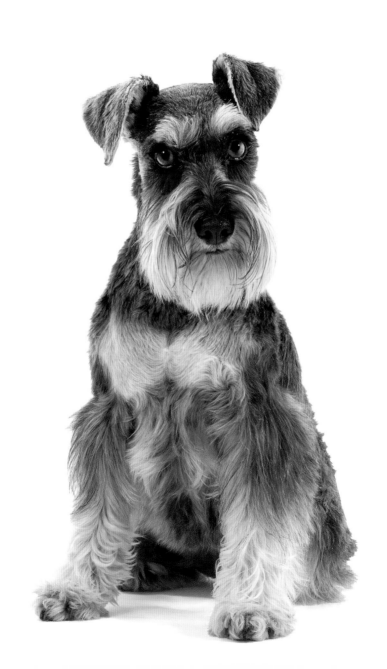

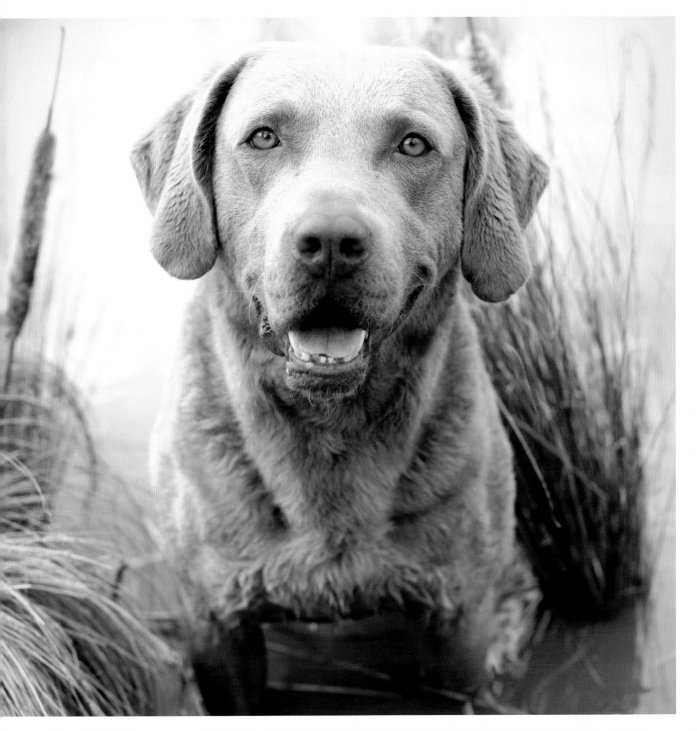

The reason a dog has so many friends is
that he wags his tail instead of his tongue.

ANON

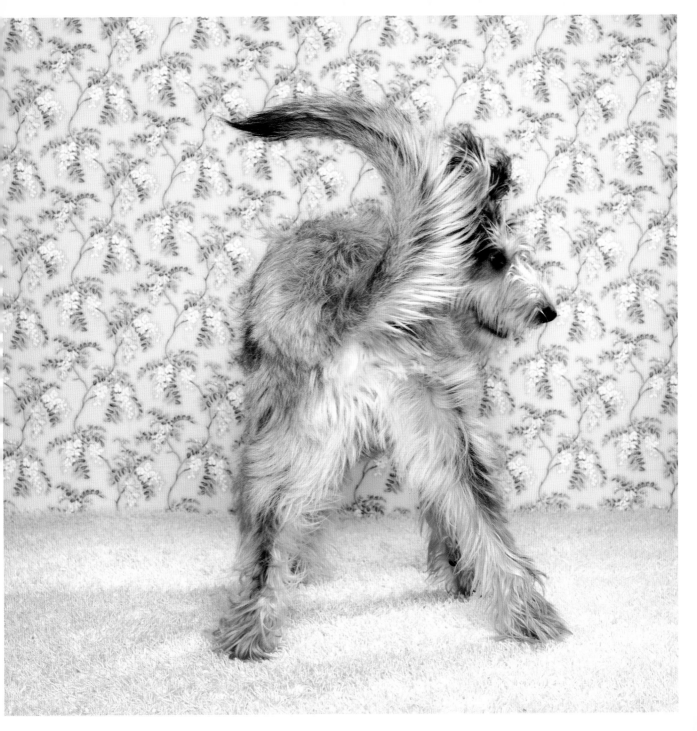

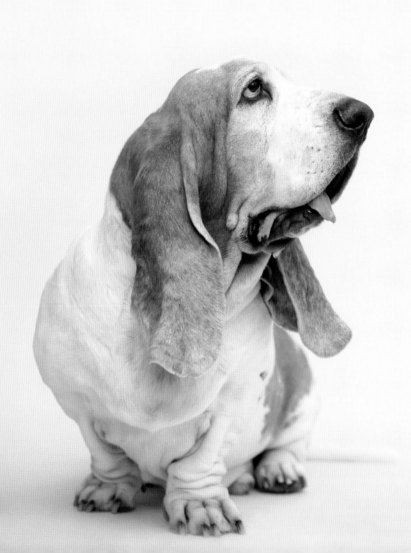

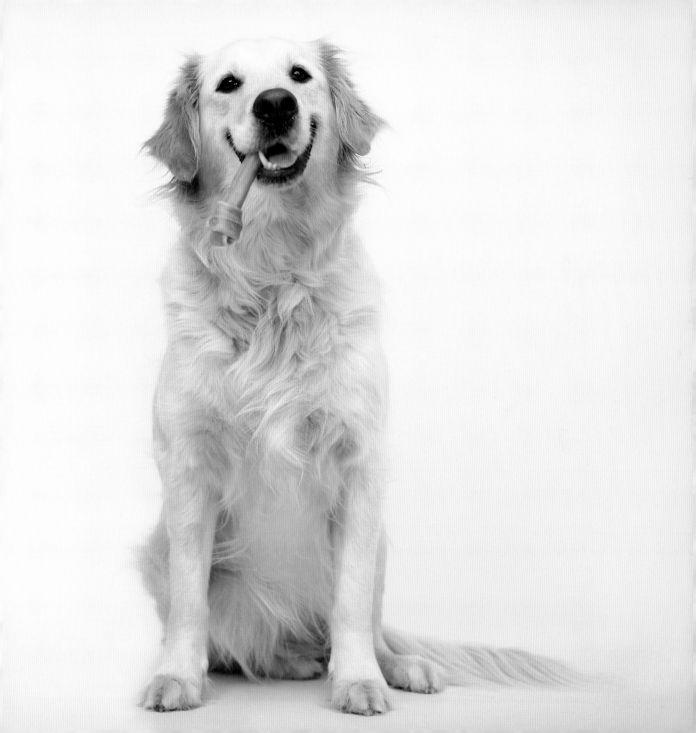

Animals are such agreeable friends—they ask no questions, they pass no criticisms.

GEORGE ELIOT

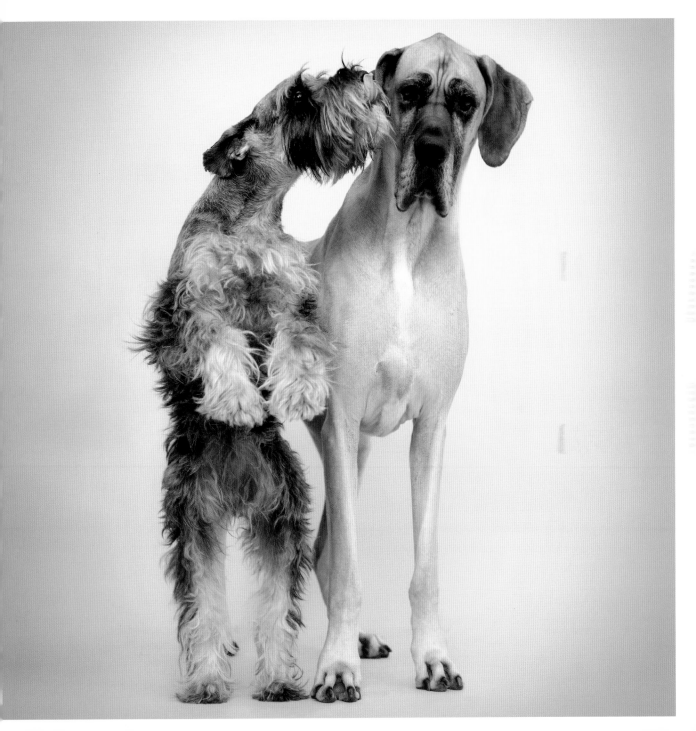

Elliott Erwitt joined the iconic Magnum Photos agency in 1953 and his images have been featured around the world for over forty years.

Catherine Ledner's work is highly sought after and has appeared in numerous publications including *Travel + Leisure*, *Dwell* and the *New York Times Magazine*.

Rachael McKenna is one of the world's most popular animal photographers, and her books, published under her maiden name of Rachael Hale, have sold over 2.7 million copies.

Gandee Vasan is an award-winning photographer whose images have been exhibited at the National Portrait Gallery in London.

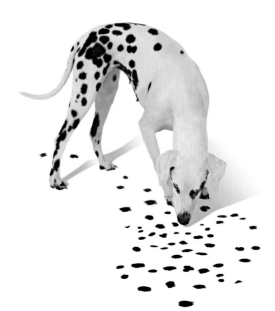

First published in the United States in 2011 by Chronicle Books LLC.

Compilation copyright © 2011 PQ Blackwell Limited
Book design by Sarah Anderson

All rights reserved. No part of this book may be reproduced in any form without written permission from the publisher.

Images are copyright the individual photographers as follows: front and back cover, endpapers and pp. 2, 4–5, 8, 9, 13, 14, 17, 20, 21, 22–23, 26–27, 29, 33, 34, 36, 39, 41, 44, 45, 48, 49, 50–51, 52, 53, 54, 56, 57, 62, 63, 65, 71, 73, 77, 80–81 and 83 copyright © Rachael Hale Trust; pp. 7, 10–11, 16, 28, 38, 64, 70, 74 and 79 copyright © Catherine Ledner; pp. 15, 25, 47, 60 and 68–69 copyright © Elliott Erwitt; pp. 19, 31, 35, 43, 58–59, 66, 76 and 84 copyright © Gandee Vasan.

The publisher is grateful for literary permissions to reproduce items subject to copyright. Every effort has been made to trace the copyright holders and the publisher apologizes for any unintentional omission. We would be pleased to hear from any not acknowledged and undertake to make all reasonable efforts to include the appropriate acknowledgment in any subsequent editions.

"The average dog is a nicer person than the average person" used with permission of Andy Rooney. "You may have a dog that won't sit up, roll over, or even cook breakfast, not because she's too stupid to learn how but because she's too smart to bother" used with permission of Rick Horowitz.

Library of Congress Cataloging-in-Publication Data available.

ISBN: 978-1-4521-0170-5

Manufactured in China

Produced and originated by PQ Blackwell Limited
116 Symonds Street, Auckland, New Zealand
www.pqblackwell.com

10 9 8 7 6 5 4 3 2 1

Chronicle Books LLC
680 Second Street
San Francisco, CA 94107
www.chroniclebooks.com

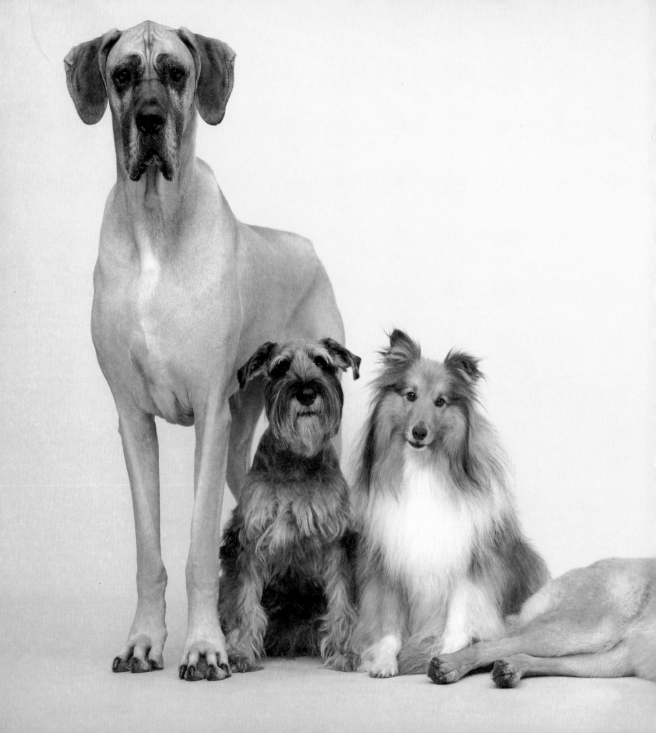